Wind Apples

Wind Apples

Jeff Ewing

Terrapin Books

Terrapin Books
4 Midvale Avenue
West Caldwell, NJ 07006

www.terrapinbooks.com

ISBN: 978-1-947896-43-7
Library of Congress Control Number: 2021931330

First Edition

Cover art by Alison Watt
Apple Orchard, 36" x 36", acrylic

Also by Jeff Ewing

The Middle Ground: Stories

for my mother and father
and
Diane & Romy
always

Contents

—And atop the barn
a weather vane knocked askew by a rifle shot,
pointing straight up, as if all the winds
were going to heaven.

—Thomas Lux, "His Spine Curved Just Enough"

In the Forcing House

The blooms, when they come, are thunderous.
The glass panes, the glass roof, rattle above us
waist deep in loam. The rioting colors filter in
through our slitted eyes and ears coiled in Fibonacci
folds like stunted buds as branches scrape their
names in the condensation and the day turns over.

We come of age tucked under mats of peat, skin
jaundiced with pollen. The sun multiplies through
the glass; we think there are many, not just the one.
Rose scent, the death-smell of gardenias propagates
a constant reminder. We don't want to leave, ever.
We want to stay right where we are, but that can't be.

We're raised for reasons that aren't ours, plans so
obscure we may never learn their point. We whisper
memories to each other, to hold onto them a little
longer. They will dry, eventually, and fall to the floor
of the forcing house, and we'll forget. Here and there
ghosted stains stir something, just under the surface.

A finger to the cheek, a hand on the head. Nights
opening in showers of stars. It was so warm once,
and green. Why can't it be always as it was within
these walls? Our veins branching and twining, little
blue rivers we trace with our fingers. Spring pulsing
inside, a promise budded tight, waiting, waiting...

One

Adios Westerner Drive-In

So much for dusk
washing against
banks of fenders,

asphalt cresting
in rutted breakers
rimed with grass.

Maybe we're done
waiting with necks
and souls craned

while Hans Zimmer
and Lionel Newman
play us for fools

and the ghosts of
our shadows troop
in elastic parade

from the snack bar
past vast mouths
poised for kissing.

How could we not
be dwarfed by
those ardent faces—

lips fat and red
as pepper slices,
eyes like saucepans.

"Give me a break,"
a joker calls over
the crackling banter

as gargantuan glands
promise undying love.
We know better,

he's trying to say,
but more to the point
we don't.

The jackrabbits
study us, thumping
in frustration.

What a spectacle
we must be, falling
ass-backward

through our lives
with the volume cranked.
Fumbling as surer

hands unknot
their puzzles above us
and our exit music

settles like dew
on the star thistle
and milkweed.

6.9 Off Humboldt Bay

Far from shore the ocean floor ripples,
shrugs and steals our footing, skews
the horizon from its beam. A single wave

larger and darker touches the beach
where elk turn to look out, ears cocked,
hooves raised and trembling. Inland

dust rises like a rug shaken out, hazes
the sky strung loosely from mountain
to mountain, settling after some thought

onto the leaves of the olive trees
above Corning. Later the trees carry the dust
into the dark, infusing the sparse stars

with a taste of the earth. There's a joke
that goes: What is the difference between
ignorance and arrogance? I don't know

and I don't care. But if by chance you do,
this rickety invention can seem—
in early morning and near dinner time

with shaken light breaking or falling
across uncowed hills—a hard place
to leave, should you be asked, in peace.

Between Kingdoms

When the fence first went up it wasn't me it meant to keep out—there were cattle
and neighbors who might take it into their heads to eat well one night.
There was an ocean down below that once had lapped here
so why not again?
Everything repeats;
the gate hangs crooked on its chain, al coda.
Rust chips at the first touch like dried blood, the gate grinds on
its hinges. A tangle of vines woven through the wire
binds in warning or challenge
a single turkey feather
yawing slowly in the wind side to side.
Scuffing the dust from the ridge back I stir up shells and the bones
of fish caught unaware by the last tide.
I feel my own bones subside
the sky press down
its fist of fog.
The houses have vanished behind me, only the old barn, the pump house,
the cellar
choked by poison oak lean against
the roll of the land, unsteady underfoot
as I follow a dry creek
into the narrowing ravine.

After the Drought

For too long the view's
been too wide, the eye ranging
too far out—past

desiccated rice fields
and cracked beds thick with
star thistle, clear

to the broken spine
of the Coast Range. When,
that is, the intervening

sky wasn't cut by
smoke or dust rising from
wind we liked to

think was the stirring
of long-gone herds or kids
kicking a ball around.

Dry clouds appeared
occasionally, teasing from
the northern horizon—

we stopped soon
enough turning our heads.
Today the rain, and

I can't see beyond
the edge of the train yard.
From habit I hear

in the nearing thunder
a freight rolling through,
shaking the mirror of

water and dazzling
a skunk that's slipped under
the neighbor's fence

without asking
to drink at the hole where
a peach tree was.

Ventriloquy

The rain has a voice,
　　　always the same voice, no matter
how many days of sun between:

the woman down the street
　　　we thought was a witch, who offered
my sister poisoned cookies, whose

hoarse cackle sent us into the corn
　　　field beyond which was another house
inhabited by a misbegotten family

of canker-hearted inbreeders,
　　　their TV always on, branches scraping
like fingernails across their roof.

We crawled on our bellies
　　　wondering if anywhere was safe,
knowing full well the answer—

we were on our own.
　　　The rain whispered through the stalks,
consoling one minute, threatening

the next, more clouds gathering
　　　above us—we had homework to do
that would never get done, dinner

waiting that would never be eaten.
　　　Where to now when that same voice
drives echoing down this street,

when it chases with crowing
 claps the storm to this house?
The quiet beforehand I feel seep

into me like cold from the ripe field.
 Rain begins tapping, wanting inside,
peace wrestles against the voice

that went so well disguised
 behind an old woman's apron. Far above,
corn silk waves like sea grass.

Picnic Day

On Picnic Day, horsey girls stand among
bunting and balloons outside the vet school,
 dust softening the high lines of their cheeks.

When I was a kid, there was a cow tethered
inside with a sheet of smudged plexiglass
 fastened over a two-foot hole in her side;

as she obliviously munched, we watched
the hay work its way through her stomachs,
 cascading in green rills from one to the next.

The clockworks exposed, was the apparent idea:
See how simple the machinery? How transparent
 and understandable our primitive mechanics?

Before you moved to Stinson, then Bolinas,
and finally a shaded grave in Olema, you carved
 your initials on the underside of a lab bench.

Others have taken your place since—
their hair smelling of alfalfa and Blu-Kote,
 their bitten nails mooned with paddock dirt,

their eyes rimmed red from crying—
but when the tour moves on, I find your M and T
 still gouged inexpertly into the knee-rubbed wood.

You were in a hurry; people were watching,
smiling at the comical way your tongue
 bobbed in concentration between your teeth,

filing this image away to recall in comfort
years later when you're safely settled somewhere
and all this madness is behind you.

These My Fenestrations

The rented window is imprinted with a vision of the world as it once was
outside—cottonwood hovering like a hen over the lawn, crossed at intervals
by the three of us.
 I feel some days the slick of the pane against my cheek,
 a pressure like string twining around my ankle; I feel
 the rub of it and catch a partial reflection moving away—
 the scene's silent, mouths open and close but no sound reaches me.
A smudge obscures the features of your face, once so familiar,
anonymous now in its occupations.
 Later, a new arrangement: the close grime of walls, fire escapes scalloped
 along the bricks—late snow falling diagonally, dissipating on the glass;
 someone's name scrawled hurriedly in the condensation.
Wiping, my hand
 concocts a river freezing, movement under ice.
 Down below a car—half bogged—spins to May.
The supposed seasons cycle, as they always have. At times I pay attention,
 note the ripples near the bottom. I watch
 and marvel at the captives in the glass—not pressed
 so much as leaves, or pinned like monarchs, they wave
 and shuttle between panes toward the scarred sash.
When I tap my Morse code, a head occasionally turns.

Pantoum of a Mild Depression

I feel it coming on
across the disordered room,
a slow hollowing-out
harmless as a baby rattler.

Across the disordered room
mouths open, close;
harmless as a baby rattler,
the TV hisses.

Mouths open, close,
words assemble and collapse.
The TV hisses.
I wait for the weather

as words assemble and collapse
around the day's events.
We all wait for the weather
to deliver us

from the day's events.
A little rain, they say,
might deliver us
the Spring we've been missing.

A little rain, so they say,
might bring back
the spring I've been missing
in my step.

If it might bring back
too that silenced voice
to my front step,
I'd be happy.

That silenced voice
that always assured me
I'd be happy
and tells me this will pass

as I feel it coming on,
the slow hollowing-out.

Taking the Auspices at Bald Hills

We invoke *lex ogulnia*
 below the Schoolhouse fire lookout,
claim our right to know our chances:

Three buzzards, then four, float
 over a lightning-struck oak splayed
above the barren valley,

a ring of shadows circling East
 and dissolving on the downslope.
A dozen meadowlarks flush

ahead of us, banking as one in
 a stutter of wings like a wheel coming
loose. Wind lays the brown grass flat.

We read the signs closely, looking
 for a loophole here beyond the fog line:
we want a child so badly.

Our empire is crumbling. This morning
 the car stuttered twice turning over,
I chipped a tooth on a walnut shell—

meaning is bound up in the belly of
 everything: you disagree, but nearly
cry at the dried body of a mouse.

The gods let us know when we've
 overreached. A goshawk screeches,
you fiddle with your wedding ring.

Two

A Wager

Below an outcrop of black lava that bent the tracks
and made the train wheels shriek, between the loose scree
of the embankment and the soft, sponging
 grass of the riverbank,
I made a wager with myself: If I caught one that morning—
brown, rainbow, cutthroat, it didn't matter which—
if I could land just one fish, the baby
 would be healthy.

It was a little game I played with myself, nothing more.
If this then that, if that then this—an illusion of control
where there was no control, only chance,
 a turning over of cards.
The cliffs on the far side leaned close, breathing haze onto
the water, the deep lies along the cutbank were still in shade.
I stepped in, cast up toward an eddy folding
 the current along hidden rifts,

and waited…knowing the strike would come, but caught
all the same when the pale belly flashed and the leader,
then the line, went taut and dove
 toward the memory of deeper water.
I set the hook lightly (out of caution, too lightly)
as the trout turned downstream, counting on the current to draw it away
from the monofilament tangent,
 the beaded treachery of air.

Every muscle straining against the pull, its will
compressed into one thought, it thrashed its head and threw
the hook…When the line went slack
 I didn't reel in right away; I stood

where I was and let the current, bitter cold with last
year's snow, push against my legs. I looked into the riffles
where the light disappeared among polished stones,
 and waited for the end—

for fate in the guise of a bent-nose mobster to wade
upstream from Reno and collect; to force me to go on, to live
without my finger tightly clenched, just once, by a hand
 too delicate for line mending.
I thought I had lost everything, I thought I would be held
to my wager—then I began to argue: If the world of the wager
were true, if that was my daughter silvering away downstream,
 then the twist of head that freed the hook

was her choice, no one else's. And I thought—
I'd better get used to that. Because one day, a day like this, a day
full-up with sun and loss, with clear water and hubris,
 she'll turn her head, smile and go—
and won't have the time, even if she wanted, to watch
the brush go pale with heat, to feel the weightless line draw "S"es
on the surface film, to know the house has forgiven all debts,
 to join me on the long walk home.

Nothing Will Hurry Her

Nothing will hurry her—
not the cleared throat
not the failing light
certainly not the clock.

Each step is measured
against an inner cadence
blood ticking time
head winds whispering.

No matter that we have
somewhere to be—
doesn't everyone?
Keep your shirt on.

She weighs each second
drops it into her purse.
None is more precious
than another. All deserve

her full attention. This
afternoon brushing out
her hair laying on
the studied layers she

is still the girl sneaking
liquor from her parents'
cabinet riding three to
a seat to the dance—

there is no hurry. No one
is going anywhere. All
is as it should be. The
waiting's just started.

Rice Burning

We drive north
through silence
 and rice fields

bristled with
stubble, blackbirds
 and herons.

The air through the vents
is sweeter
 than it should be

but sweetness
about to change
 into something else

like candy held
in the mouth
 too long.

Our eyes water
we taste ash
 on our lips,

a crackling sifts
like static through
 the window.

The flames are
not yet visible
 just the smoke

flat as a dry cloud
pulled taut
 over the fields

and the lights
of the county truck
 flashing.

Someone at least
is watching, tending
 this smoldering

that could so easily
get away
 from him.

Elk Carry Their Hunger into the Day

The fog originates in the muzzles of Roosevelt elk
bunched beyond the dunes, curling into the suggestion
 of trees on the bluffs, trunks and needles blurred soft

as trees recalled from the green remove of years. A stray
calf's bellow weaves through the brume washing over us
 where we sleep on the sand having left the tent empty,

the night too mild to shelter out of, condensing along
 the hairs of our arms, kinder and less emphatic than rain.

My daughter, almost in the fire, stirs, her bag sooty, hair
matted wild as it used to be when she paced out the long
 mornings under the rilled limbs of the oak, mothered

by bees and a family of squirrels, unrooted from
the night's soft swirl of stars, her head thrust forward
 against the pull of the day, the close-tethered house,

calling again and again at the far outer bound of her range
 in a voice pitched to gather the scattered world to her.

Swimming Walden Pond

In the uncomplicated light
offshore of the cabin site, knots
of kids on bright rafts bob

in lazy geometry. Embrace,
Henry said, each regret as a friend—
I try, imagining my fond

mistakes lolling fat and
happy on souvenir towels dumb
to their progeny's drift.

Bellies flopping, they
galumph and splash beneath
barbecue smoke palling

over the water. One raises
a hand to wave. Enduring is a
simple matter, a deliberate

progression from shore to shore.
Reach and pull, reach and pull.
"Never look back," he said

another day, shielding his
eyes from the glare. "Unless you
are planning to go that way."

On the Death, by Trampling, of a Man in Modoc County

The sound of hooves
on packed dirt is unexpected,
so loud suddenly, and close.

He removes his hat,
brown felt, drags his sleeve
across his forehead.

He sees his daughter
on a late summer day, sandals
flapping down the sidewalk

ahead of a storm building
some ways off. The sound
of hooves is louder now,

even closer. He looks
straight up and sees a scrap
of white cloud torn

from something larger
traversing the blue nothing.
The rest is flown.

Some people,
when they hear hoofbeats,
don't think horses.

Hardpan

The horse lay in the field
for three days
before someone came
to put it down.
The tenants were inside
cooking meth, their kids
crushing Sudafed
and slurping ramen.

It had been years
since the field
had known any crop
but weeds and burdock—
the kids' legs
when they came in
from playing were red
with spurge rash
and scarified by nettles.

When I was young,
there was an orchard there,
a pear orchard—the fruit hung
from the trees in a way
that reminded us
of the girls at school
we lusted after,
their skin going
slowly gold
in the sun.

Wind Apples

The orchard, ghosted
in fog, rises in ranks
toward Orion.

The last scrimped
fruit thuds to ground
like footsteps

working downhill,
shuffling through dry
leaves. I meet

myself coming back
when I can't sleep
and the trees—

heads bowed, branches
clawed with age—
rattle my nights

with remembered harvests.
When the smell of
cider on caught

breath and the spill of
light ripening on
moon-washed skin

drags me uphill again.
One leg stiff with
cold and wear,

my blood thick as
winter sap, I find
our old spot

and eat myself sick
on wind apples,
lug after lug

carried in unforgiving
gusts down from
the gray crest.

Three

In Shade Her Scars Nearly Vanish

I won't call it dappling, the blithe way light is
often described falling brokenly through leaves—
it's a deeper shade, thirstier; burnished, maybe,
though that's still too artful—standing with her
arms crossed self-consciously, a diffident stance
I've seen only old trees assume, oaks pecked
hollow and stuffed with acorns, bark fallen
in sheets at their feet, their crowns arching far
overhead (she's let her hair grow out in that
wild halo) with here and there in between one
spiked with ash, lightning-struck naked on
the side of a hill. You can hear the wind lisping
inside, the dry rattle of the smaller branches;
later, when full twilight comes on, everywhere
is shade and moths rising blindly through the
grass like living ash floating up and up and up.

The Eccentric Exterior of Which
the Clocks Talk

Outside noncommittal clouds puff and congregate, a pen scratches
its way across the page like a cat at the door wanting out.

This is what she remembers: thinning hair parted down the middle,
a turned row waiting for rain; the massive desk's griffin legs hackling

a burled back to the sky. What arcane laws New Haven's weather
obeys! A pelagic light off his horn-rims reflects incongruously a lake

far to the north they'd traveled to once when shy and frightened
of things he could banish with a cough and a kiss. Snow fell in flurries

thick as Paris-Brest—a blizzard out of Nova Scotia against which
he built a pyre from dire print (the world hurtling once more to its emphatic

end) and crumpling Armageddon to a ball drew from a café match
a blue unlikely flame. As if from nothing; all her everything from nothing.

While the old clock rattles its birdseye crystal, seconds flee like steam
to the rumored poles, his pen slings meridians in tireless transit—

and rapt to the tambour on the mantle, a souvenir from Courmayeur,
her knit hands await Mont Blanc's ascendance from its craquelure col.

Childhood as a Series of Concussions

We played five-man wiffle ball on a diamond carved
out of horsehead weeds, my granddad's elaborate windup
a ruse to get us to swing early and often, grinning
and humming "I've Been Working on the Railroad"
just loud enough to mistime our swings. Flies rising off
the lake, following the tang of mustard up the hill plain to them
as a deer trail stamped through grass. My father cut
the diamond with a second-hand mower—Briggs & Stratton,
the blades dull and nicked. Only a fool (which he wasn't)
would use a good blade on that ground. I can almost,
though not quite, feel the lip of the Country Squire's roof
under my knee, watching him pass up and down the first base
line, squinting for precision. Likewise I can almost hear
the zip of the rock that cracked me square on the forehead.
A red filter on bright sunlight, the car stopping above
the old man's house. He kept rattlesnake skins and snapping
turtle shells tacked to his doorpost and offered up soup
made from the scooped-out meat—dancing now from
foot to foot, clanging his copper bell and yelling, "Fire! Fire!"
My father and brother scrambled down the hill to put it out
while I stayed flat on my back in the closed-up station
wagon, counting the missed pitches between here and there,
making a point to remember the view, as I turned my head,
of blue sky, green fir tops, and whitecaps breaking over
the hooked beaks, tinted with blood, of man-sized snappers
singing: "Someone's in the kitchen I know oh oh oh."

When the Dead Walk in Dubuque

They stroll the bankside path in Eagle Point Park, pointing as any tourist
at the mass of the Mississippi churning past, comparing it perhaps to something
in the underworld—"rowdier than the Styx," "lazier than Lethe"—or simply

tossing rocks to watch them disappear. They contribute little to the economy
or to the cultural cachet of our city by the bluffs—not one has opened an account
at Younkers or ascended Sinsinawa—no, they shuffle and gawk, waiting for

god knows what. Their wounds show plainly (those who died in violence) such
that we must cover our children's eyes for half the day. Where does the pride
in their stance come from, is death such an accomplishment to rub in our faces?

Near sunset they gather by their own graves, squint at the meagre inscriptions
that pare their lives to triteness, arguing with one another over their neglected worth.
Pushed aside by the past, we're shouldered from the path of right to skitter down

mud embankments in entirely inadequate shoes. Priests retreat to their sacristies,
ministers amend their unguents, Irishmen and Germans fall over themselves
to accommodate those never given a second thought. "Shall we gather at the river?"

they sing, voices swooping like swallows despoiling the Motherhouse for gnats
as they do near dusk at the tail end of summer, the dead among the living hijacking
all we have selfishly built, swaying on the shore, up the elevator line, as if to say:

How can one leave such a paradise? Would you not too, given the chance, gather
a final time here as once when young with arms weakened by distance all
that was lost and left in the rabbit hole of your short history, clutch your earthly

tchotchkes too tightly for even death to steal, gather once more my unlikeliest
friend as if some life or other depended on it in the blue shadow of the Ice Harbor,
here by the river, within spitting distance of the beautiful, the beautiful river?

Longlining

I embrace the long line the way the manx embraces the mouse,
the way the ocean pulls the rock close to whisper in its cupped ear
 the single word "gravel,"

the way our first touch in your driveway with your parents just inside
arced across the ignition, sparked the engine to life, danced in the seats
 and set them ablaze—

oh how we went up! An aurora of light and smoke curling out the window
into the fog, black into gray, today into tomorrow, grateful and smiling,
 how we flared and rose—

and in the morning two mounds of cooling ash, soft and crumbling,
into which your little sister dipped her finger and drew on her forehead
 the outline of a heart.

Under Sandhill Cranes

Two or three sticks of cherry molder
in the basket by the fireplace, old
ashes have drifted in the corners. A spider
web as gray as my hair loops from
the flue. Out front, under the overgrown
camellias, I've stacked the rounds
from an oak branch that fell at the end
of summer. The wood will be cured
by next fall—maybe we'll have a fire
then, the three of us huddled in a half-
circle watching the flames, close
as only fire can bring us. I can smell
through forced heat the must of smoke
tucked into jacket pockets, and hear
in the clacking of a flock of sandhill
cranes passing over the pop and crack
of pitch igniting. They say—people
do, not the cranes—that heat is heat
no matter what the source, and don't
see any loss in the conversion.

Lazy Eye

It sees what it wants and what it doesn't
it doesn't—ignores, for instance, the
host face striated as bristlecone bark,
a lentigo tracing the Caspian shore.

General outlines are noted, an overall
impression glazes the retina—a shoebox
diorama holding me fast, leaden feet
glued in the shade of q-tip trees. Doing

the work of two with half-assed effort,
it leaves most depths unplumbed:
What do you see that I don't, squinting
into the poorly delimited sun?

At night, beads well and fall—I find
them in the morning distilled to crystals
in exchange for which the Jewelry
& Loan trades a glyptic of seasons

turned with autumnal obsession,
a quart jar preserving the last outcast
breath of the last *arctos californicus,*
and in rubicund Cambrian amber a photo

of us on the South Rim framed by an
uncertainty no perfect eye can fathom—
rock and pinyon, and the river far below
fogged by unspeakable distance.

Michael Collins

In the kidneyed design of spilled wine, the future
presents itself, roseate and transparent as I've heard
diseased cells sometimes appear. I stand for a second
transfixed like an amateur sideshow man guessing
the weight of the past, lifting the mothers of old friends
grown lighter each year until they just slip away.

I recall those years before you moved away
from our unaspiring town (within which the future
could gain no foothold) as a time of ironclad friends
bolted together like convicts, fumblings overheard
from the stairs blueprints to our clumsy guessings.
You weren't the first of us to fail, or the second,

to slouch home to your dinner, to ask for seconds
and try to forget the deadening feeling of fading away,
of dissolving like an old photo. Then and now a guessing
game, a long blindfolded march into our futures
that allowed no missteps—we believed what we heard,
did as we were told; accepted as fact that friends

were dead weight. Come spring we shed those friends
like husks. Later, lying awake counting the long seconds
till morning, I might hear a voice I hadn't heard
in years, loud and laughing in my ear. I'd shoo it away
like a fly, turn to the other side—nothing but the future
mattered then; it wasn't a time for second guessing

as far overhead Michael Collins floated, guessing
correctly that he would be forgotten, that his friends—
bouncing kids swinging a nine iron—were the future
we all deserved. His fame measured in seconds,
still he wished them both well as they lowered away.
He's the one I think of most, whose voice I hear

as I stand alone on an eroding shore, the bulk of the herd
lowing in the distance, and study the clouds. Guessing
which will inundate the fields and which float away
harmlessly, how much rain it might take to separate friends
from the merely at-hand. Days dissolve in seconds,
the past denies that one long night ago it was the future.

A Motel in Stanley, Idaho

Wind soon undoes the snowfall draped across the fir outside my window,
a bulb pops from the cold on a Christmas string crowning the fence,
no tracks are left to mar
 the landscape, not even my own—an embarrassment
 of riches, the stars unbind
 their bestiary.
 The coiled ice of Iron Creek cinches tight the meander where we once sat
in chairs carved from the last bones of old growth.
 What good does remembering do, what possible use are words when
 every impulse is drowned by second guessing and trucks downshifting
 on the grade up over Galena
 toward heaven?
 If I could sleep, I would sleep.
 The mountains cup the moon like a flour moth, its wings flitting against
their palms tentative
 the light between drifts.

Four

The Dunes

The dunes rise and shift in the memories
of fifteen kids caught between the pull of waves
and the press of parents picketed in rows
amid beach grass clumps. They rear again
like wild horses, backs unbowed by taming,
nearly as high though in dimmer detail.

They move against and with time—a lesson
taught over and over (and just as soon forgotten)
by the fins of roofs breaching the berm above
the estuary, by rust-clad chairs rising empty
at high tide. Wind pluming their peaks, the
dunes move in our sleep, dreamt and redreamt.

We remark on the persistence of forces
shaping the dunes, on their alteration from some
significant date to now. Forgetting how we
turned our backs once to them, our attention on
the ocean's surge against our legs, the slippage
underfoot as wave by wave drew us deeper.

We repent how we rode the dunes away from
the houses, heels kicking loose knots of pale
grass—not quite green—that bound them for
the moment to the land's edge. The dunes,
for their part, have no recollection. What marks
we left are somewhere off Bermuda now.

Toward dusk the wind dies, as it always does,
a little hiccup in the dunes' progression. The stars
burn their cigarette holes, streak the long grass

with half-drawn shades. Against a sunken fence
the dry husk of a blue crab glows, illumined pink
from within, snagging your dress as you pass.

West Through Sunflowers

The town in the fat-grass prairie of southern Saskatchewan floats in a blazing
sea of sunflowers, miles of them, gray heads slightly bowed, yellow manes

rippling in a breeze that's tinged yellow too—I've seen it for myself, touched
my fingers to my face and brought them back yellow. Everything in the town

carries that oppressive cast, even the shadows, while contentment tints to blue,
sky and water and blood untouched by air. The summer before a priest

was killed by a hitchhiker, his throat cut, body dragged into the rattling stalks.
His neighbors can't forgive the slash of his black coat across their yellow canvas

or his feet mud-caked as if uprooted, his face turned unnaturally from the sun.
The faces of sunflowers are turned always to the sun, pivoting day to day

east to west, jealously watching its passage, the slow migration toward Alberta
of those stranded travelers who've said the hell with it and started walking into

the undifferentiated distance, their beat-up jackets and sagging packs turning
transparent in the haze of dust and misunderstanding until just a trace is left,

a hint of patchouli or weed—then prairie again, yellow wind and a worn blue
baseball cap dancing down the centerline, its brass buckle clicking the pavement.

Nordmarka

The woman holds
the door half-open
against the blowing rain,
 eyes my t-shirt,

my rain-blacked jeans.
She takes me in because
she has to, because
 she would be the kind

of person she despises
if she didn't, the sort she
lives out here to be
 well away from.

She shows me to
a shed where space
has been cleared
 between drying racks

glinting with vellumed
scales. I listen to
the thrash and crack
 of the storm—

rain running across
the roof, wind
whistling through
 the trees' broken teeth.

It's easy to mistake
luck for fate when it
speaks in a lilting voice
 and later on, after

the storm's cleared,
brings a plate of
braised beef and a cold
 bottle of sommerøl.

On the Front Street Massif

Here the light through blinds is blinding,
the water sheeted and stamped with
the reflected city in whose windows
clouds congregate like salmon.

At dawn the new forgotten dip their feet
and splash their faces, roll their days
palm to palm like dice, bone pips
summing a Chaldean number

that will make no difference. You sip
your coffee; it's nearly cold. To rise
from there to here seems impossible,
but it's been done, as Everest

has been ascended by schoolteachers
rationing and scrimping—crackers for lunch,
a bus pass scapular; reading each break
from Rébuffat and Messner—

dreaming of the view up the Khumbu
past stiffened Mallory's finger tracing
the last pitch—till on the scalloped crest
the preoccupied world supines itself

as a college girl on the beach at Capitola
might, half asleep, crook a pearlescent arm
above her eyes to watch a pelican
tumble seaward like a stone.

Listening to Mahler While Waiting for Oroville Dam to Fail

All afternoon the levees fidget, clearing
their throats over the swollen strains of the
Bavarian Radio Symphony. Anchoring oaks
cling to their eroding adagio, boils churn
along the bank. You can hear in the eddies
of the long second movement trumpets silting
up the channel a piccolo's carved. Rain and
more rain. "If nature could express what
it needed to in words," the man himself said,
"it wouldn't bother with inclement music."
The evacuations proceed, the long line of cars
and pickups drifts south. Only the mind dares
compose a grander theme through violence—
the way the memory of an earlier love's tumult
tears against the riprap of long-settled bones.
Who wouldn't, in such a situation, tilt his head
back to feel the notes trace their way again
down his cheek, and listen in the lull between
for water to call the last suspended bow to rest?

California Death Index

The north wind turns the pages of our dog-eared book, its painstaking print
fine as webbing strung with dew across an open gate before anyone's stirred
or departed.

Here, names shed in a too-vibrant season persist under the shadowless sky,
scratched with a broken stick into dry ground that feeds no roots, only brush
fires and dust devils—

something stirs to the east, but west was always the cardinal. Night falls
elsewhere while we hold the day's unraveling close, the sun a red stain
spilled across brown hills

onto an almanac of obstinance undone by caring at the last—oh we'll slip up,
we always do, find ourselves cradling a friend against the friendless sprawl
of a summer night.

Reintroducing the Wolf

There's no moon
tonight to dress the lawn
or drape the low bed,
the only light the clock
fallen from the nightstand.

Outside, the street bucks
the sidewalk's bank, a
transformer hums. What stirs
an unquiet mind from
its preoccupations?

The wolf enters panting,
muscles tensing under
the sheets. A tentative half-
snarl culled from base pairs
breaks from my throat as

I lope through waist-high
grass. Birds without number
hurtle above me, cragged
wind keens from my
north, blue as inlaid ice.

How sweet the loosed
blood, how blinding
the heat sweeping from
the backs of falling sheep
like blown snow!

Beside me, my wife
stirs, turns her back. With
no sound (no bleat or
whimper) the latest star
to die tonight blinks out,

and in the hole it leaves,
I fall back into myself—
the taste of blood still fresh,
my pale skin clammy
and strange to the touch.

The Brave Father

How can you look death
in the eye and tremble
with the sun so warm
between clouds, not laugh

out loud as it rages
through the house raking
dishes and slamming doors
like a newly sobered drunk?

It's the wind, I tell my
daughter, as it roars out
into the yard to pin my father's
empty glove against

the fence and shake
the branches of aged saplings
in its fists as if wringing
water from a towel.

Beside me she's thinking
how it will be when it's us
enacting this, when our
days together crack and run

out on the floor. She cries
harder, and I see how
wrong I've been. If I was
a real father, a brave father,

I'd have been crueler.
I'd have made her hate me,
so that when I'm gone
there will be none of this.

In

Above and below
all the quiet, idleness
carves its course through
the neighborhood—

cars sink on their struts,
vetch and cow clover
in standing waves breach
the buckled sidewalk.

A girl in passing turns
to look this way and quickly
moves on; the last thing
she needs is to see

her pinched reflection
thrown back once more
from one more closed window.
We likewise turn away

from the rioting quiet
and over dinner watch evening
in the silverware sail west
to the Farallons. Later

a dove smacks the door
and doesn't rise, the sound
taken a glad moment for
someone knocking.

Five

After Ash-Scattering

At a horseshoe bend on the Carson
we use a knob of blood-grained wood
 my brother finds
on the bank below our camp
to scoop my father a little at a time
 from the box.

We remember him in whatever way
works best for each of us as he sifts through
 the fingers
of the meadow: A joke, a story, a song finally
that none of us can bring ourselves
 to sing.

The blue heads of lupine nod, a Paiute
cutthroat rises to take in a fallen baetis.
 From behind
the ridge a golden eagle glides, harried
by a smaller hawk, circles once
 then vanishes west.

How are we to parse these messages?
What irrigant belief will bring him back
 in flower next spring?
We put our faith in family and moving water
seeing in each inherited river a sure
 discernible course.

A breeze comes up just enough to cool us
without disturbing the dusting of ash
 on the grass.

My mother puts the scoop in her pocket.
The Carson talks my father to his stubborn
 woodchuck sleep.

I Looked Away

for only the time it takes
to undo a knot maybe two
no longer than the out-
blown breath

from an unfit body needs
to fog the upstairs glass
the heart drawn there
to withdraw

a dull blink of exhaustion
three slow lowerings
of paperwhite lids
revealing

a meagre view of stunted
pines and late snow gone
gray what a world
vanished

while I wasn't looking
do you remember how it
spun just yesterday so
freely

with so little effort
walking toward the river
we saw a band of geese
their wings

heavy under them
guarding in some soft
reserve what strength
remained

to make their way back
when the weather turned
a lesson forever lost
on us.

Leaving Bergen

On the path down Ulriken the stones rearrange themselves.
Halfway along there's a gap in the wall with a cross affixed at an odd angle.
Below, more stones
and a gravel beach.
I grow tired of walking and of my own company, stop to rest
on the slope above the harbor. Wesselsgate 7's blue door nudges the sky
with an elbow.
A house too can lose its way, heckled
by wind slashing from Finnmark.
At the northernmost end of Sandviken, Swenson loops his ropes
in a cross beneath a pallet, raps twice on the hull for the crane—
water rises in the hold, the moon
glides across ice, left to right.
Here, beside the tracks of a marten, I bury a part of myself
beneath hardening snow as a door opens onto a hallway,
then to a moon-yellowed room alive with talk.
The days are numbered, if not in precise order.
A bull elk sips the first unfrozen stars.
I'm welcomed
for the last time.

A Pasture

There were promises
 in the beginning
beautiful in their
implications

outlines of a world
 drawn in
charcoal and hatch
horses grazing

children running light
 filtered through
aspen leaves folded
along their veins.

Dividing the pasture
 we work past
the light's failing and
don't think too much

about what we've
 done without—
the outdistancing feet
sprinting ahead

the volumes of grass
 unopened
word after green word
turned heedlessly under.

Evening at the Downturn

I don't think I'll miss,
she says, any one thing
more than another,

implicating, besides
the light jalousied through
the pergola, a blue jay

diving to pluck
a hornworm off a tomato
plant. I acclaim

the perfection
of the worm's ugliness,
its near-invisibility

on the stalk.
She recants, denounces
the ugliness in

its perfection,
the green leaf tips already
turning brown.

Even here under
the beauty of an evening
at the downturn,

our divided loyalties
show. Two sides to the same
coin tossed refutably

up: the radiant
flash at apex, the dusk-
leaden fall.

As the Crow Flies

From sufficient height we make a kind of sense,
 the designs we scratch in the dirt and dry grass
 appear reasonable, if desperate. The white stones
 like rows of teeth, roads like knotted shoelaces—
we move and a wave presses the crow's belly.

Two fences (one stone, one woven slats) rise and fall
 across sheepback swells under clouds
 that threaten more than they can deliver.
 Rain falls where it will, and where it won't we root
ourselves deeper, dowse blind to hardpan.

What madness can rival the sight of us scrabbling over
 ridge and moraine? The crow feathers his wings,
 hovers a black eye above the country bent under
 its load. Pinfeathers whirr like cards in spokes,
the shrill cry—gravel on tin—rattles downslope.

Small wonder his straight flight from A to B
 confounds us. We hunch over cooling coffees,
 arrange our chairs on listing decks, while all the
 tumulting glaciers carry on—without us, at last,
having had our say. An era borne in error.

The light's gone out, my headless chickens. We move,
 such delicate dead, by sheer nerve memory. Out along
 the bluffs brimming with lupine, the blue
 on black wing clapping overhead. Our fall gentle,
not to wake the Pacific from its dream of us.

Leaving the Party

Word always comes too early, in the dim
purgatory just before sunup. Is this how
it happens, life diminishing little by little,
the brightest lights going out first?

You compared it once to a party, and why
not, even if not the kind you'd throw—
rage and ruin, wasted friends spooling out
in the corners, the music lousy and too loud,

one thing after another you'll want to take
back, and in the end the cops breaking it up.
In between, though—you say from out there—
so much beauty worked from room to room,

conversations spun that would carry you
through other, longer nights. How in hell was
so much held so lightly? Alone in the tapering
hall you hear the bass thumping through,

the outline of a song you can't quite name
(you watched a lone girl dancing to it earlier,
clumsy and rapt, whirling the smoke into
undreamt-of designs). You draw a slow finger

down the glass; the first hint of frost touches
you from the other side. Your ride's on his way;
the night's breaking up. The least of us will stay
longest, as a reminder that time is not the enemy.

Looking Up We See More Than Is There

My daughter teaches me the names
of the clouds—not cumulus or nimbus
or any such vaguery—but Carlisle
and Heather and Sawhorse, Handsome
Lunchbox and Home Before Dark.
The one with crossed eyes and chewed
lower lip she calls Rebecca. They're
born and die in the space of an afternoon.

She pronounces each with careful
enunciation; I'm an old man and slow.
She understands how they're made,
that they're only water. She knows she
can't call them down or ask them to
stay behind. And when they blank out
the stars, she scolds them a little but
never holds their intrusions against them.

The cold wind that follows she doesn't
blame them for, or the rain. Rebecca
would never batter her window like that,
or split a tree down the middle. She notes
them all in the dust with a nutgrass stalk,
but what's in a name? When she calls, I
answer. When she outgrows me, I turn into
a zebra and scatter myself against a hill.

Meteor Shower Over Gualala

The sudden lights flared and fled,
flung careless as cigarette butts;
you traced their dying arcs and
proclaimed our inconsequence:
how dull our paths in comparison!
laying a finger beside your eye

to attest its reliability, unaware
that the retina retains its ghosts,
resurrects them on occasion to project
across the same night sky. I step
to one side to see if you follow;
then back, alone, as seems right.

Someone's worn a spot, trampled
and littered it with pint bottles;
they've cut away the upper limbs
as one does at an uncertain age
to make room for the crowding
constellations. What relief

the clouds are, rolling in from
the west. I attributed a purpose once
to habit and a permanence to
accustomed desires, until the hunger
that carried me forward lost
its fascination. I remember

the night and the place: a similar
hill above the ocean, sometime late
in August. My eyes heavy-lidded,
the once staggering explosions
of Perseus a few smeared stars
dragged across the summer sky.

Daylight Saving

Tucked and wrapped, soft-sided
as a jelly donut, similar too in the slow
leak from its crumbed side,

it ticks at times faintly, a joke
I think being played, nature mocked
by stereotypes: as though seconds

were tender gears whirring
rather than pennies grimed with starlight.
Its heat, faint but real, trails

me through the streets, melting
ice from the sidewalks and raising steam
from the folds of my coat.

I run my thumb across its
worn face—a deathly bright copperhead
coiled in its shed self, years

sloughed in chattering husks.
Listen to us, our young voices so trusting
in the sun's call and response,

the Ollie-Ollies sung from
either end of the street at its sinking.
Fireflies blinking on and off.

Here, then gone. We sense each
other in the dark, hands outstretched beneath
humming wires, holding on to

a last wedge of pearled sky,
believing we can by combined will call
back to our feet the just-kicked can.

Acknowledgments

The American Journal of Poetry: "In"

Arroyo Literary Review: "Adios Westerner Drive-In," "Pantoum of a Mild Depression"

Ascent: "6.9 Off Humboldt Bay"

Atlanta Review: "As the Crow Flies"

Beloit Poetry Journal: "Rice Burning"

Bridge Eight: "Between Kingdoms," "I Looked Away," "Nordmarka"

The Cape Rock: "Nothing Will Hurry Her"

Catamaran Literary Reader: "After the Drought," "In the Forcing House," "Michael Collins"

Chattahoochee Review: "Hardpan," "Longlining"

Clade Song: "Leaving Bergen," "Evening at the Downturn"

COG: "Picnic Day"

Columbia Poetry Review: "In Shade Her Scars Nearly Vanish"

Columbia Review: "Childhood as a Series of Concussions"

Connecticut River Review: "Listening to Mahler While Waiting for Oroville Dam to Fail"

december: "On the Death, by Trampling, of a Man in Modoc County"

Hamilton Arts & Letters: "The Brave Father"

I-70 Review: "After Ash-Scattering," "The Dunes," "Ventriloquy"

Lake Effect: "When the Dead Walk in Dubuque"

Monarch Review: "Reintroducing the Wolf"

Penn Review: "Taking the Auspices at Bald Hills"

Saint Ann's Review: "These My Fenestrations"

Split Rock Review: "Under Sandhill Cranes"

Sugar House Review: "California Death Index," "Lazy Eye,"
 "A Motel in Stanley, Idaho," "Wind Apples"

Tar River Poetry: "Elk Carry Their Hunger Into the Day,"
 "Swimming Walden Pond"

Timberline Review: "Leaving the Party," "A Wager"

Tule Review: "The Eccentric Exterior of Which the Clocks Talk,"
 "A Pasture"

Willow Springs: "Looking Up We See More Than Is There"

ZYZZYVA: "Daylight Saving," "West Through Sunflowers"

About the Author

Jeff Ewing is the author of *The Middle Ground: Stories* (Into the Void Press, 2019). His poems, fiction, and essays have appeared in publications in the U.S. and abroad, and his plays have been staged in New York, Los Angeles, and Buffalo, New York. He has lived in Chicago, Santa Cruz, and Bergen, Norway, working variously as a technical writer, editor, newsroom PA, copier repairman, forklift driver, longshoreman, and salad boy. He now lives in Sacramento, California, where he grew up.

CPSIA information can be obtained
at www.ICGtesting.com
Printed in the USA
BVHW072355180521
607636BV00005B/548